BUTTS
ON
THINGS

@BrianCookArt

PAGE STREET
PUBLISHING CO.

BUTTS ON THINGS

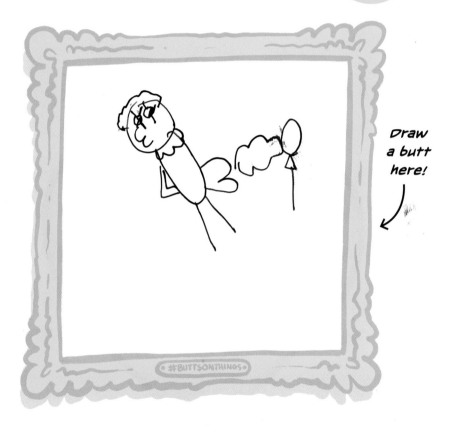

Draw a butt here!

#BUTTSONTHINGS

BY BRIAN COOK

PAGE STREET
PUBLISHING CO.

Dedicated to everyone who has liked,
shared, laughed at, and continued
to stalk this series.

Howdy, everyone! Welcome to my book!

When you were in grade school did you take a test that told you what careers you might be interested in? I did. But oddly, artist that draws butts on random things was not on the list.

So then, how did this series start? Valid question. I always knew I wanted to be an artist. I've been drawing silly things ever since I was a kid eating Oreos and reading *Calvin and Hobbes* comics. As a freelance illustrator now, I still doodle silly ideas every single day.

One day in my studio, I glanced at my coffee and imagined the cup's hot sleeve as a little shirt that the cup was wearing. I thought it was funny that it was wearing a shirt, but no pants. So naturally, I did a quick doodle of the cup with a cute little butt peeking out under the sleeve. I posted it on social media and tagged it #buttsonthings. People seemed to think it was funny, so the next Friday I did another . . . then another. It became my tradition to celebrate making it through another week. That was over five years ago now and I haven't missed a single Friday.

Why has this silly little tradition gained the following it has? I think it boils down to one unavoidable truth: Butts are funny. It's really that simple. Still not sure? If only I had brought some examples to help me convince you . . .

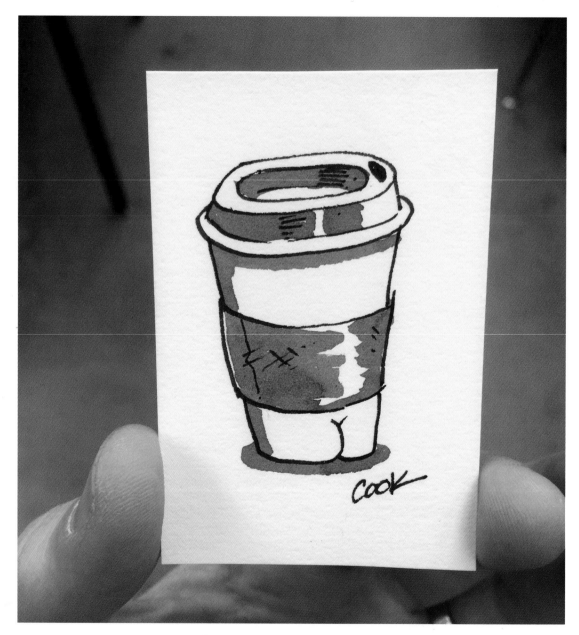

The Very First Butt
Friday, February 5, 2016

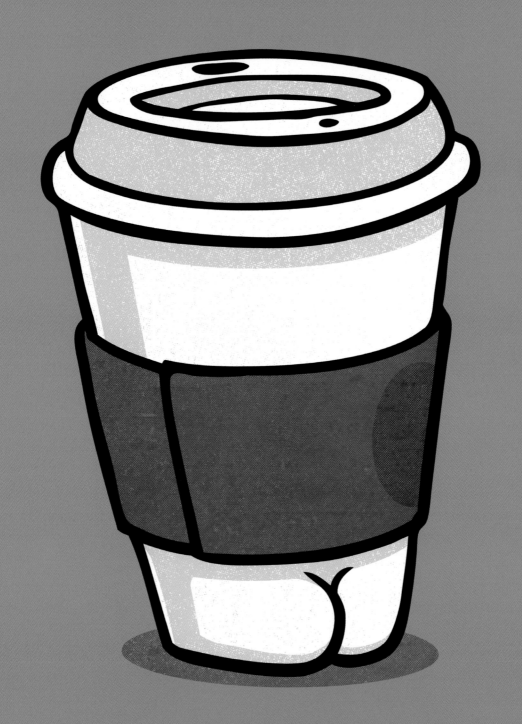

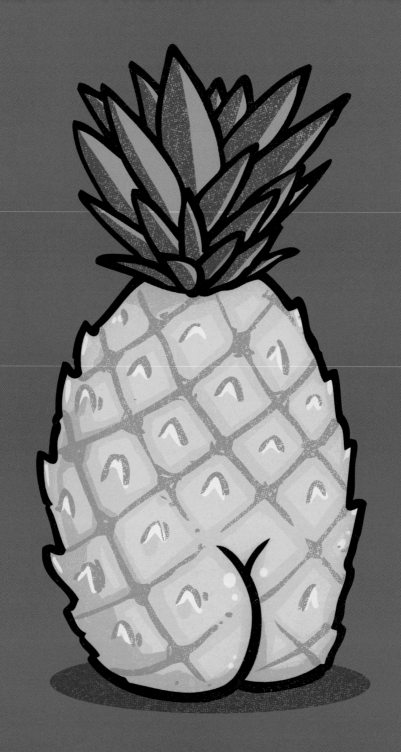

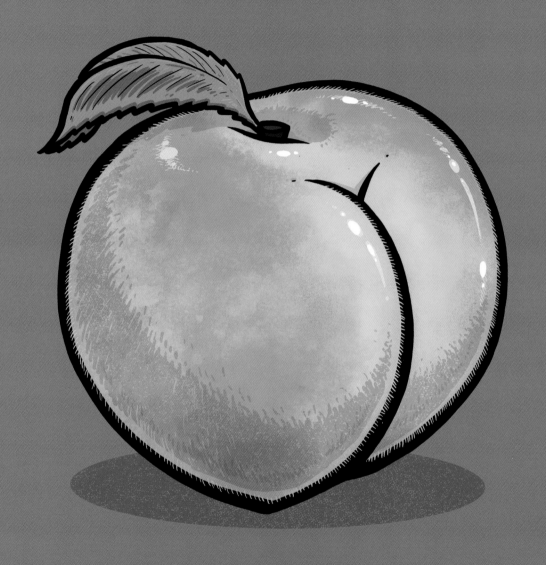

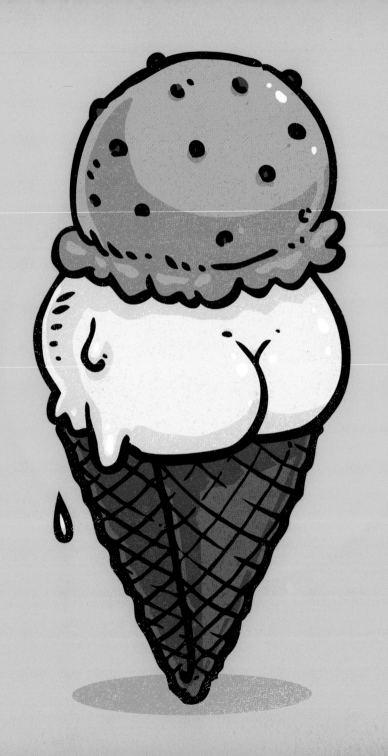

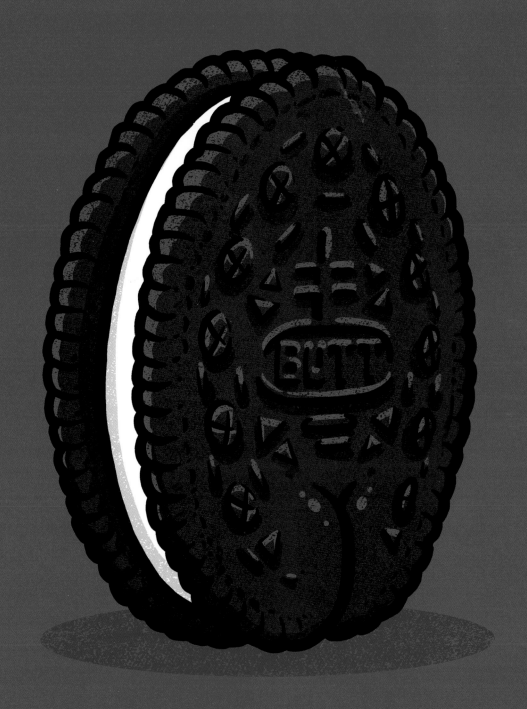

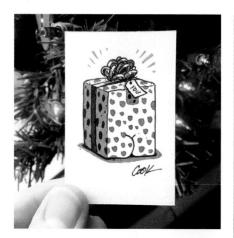
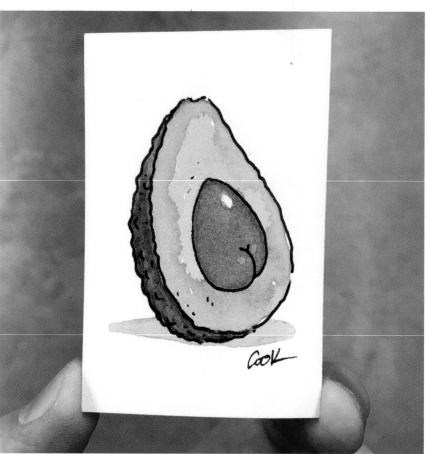
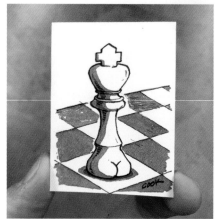
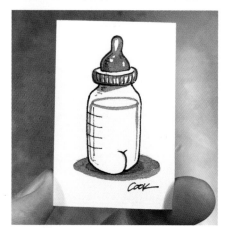
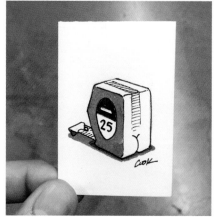
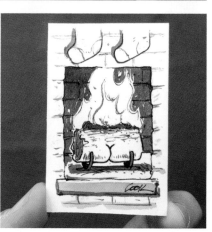

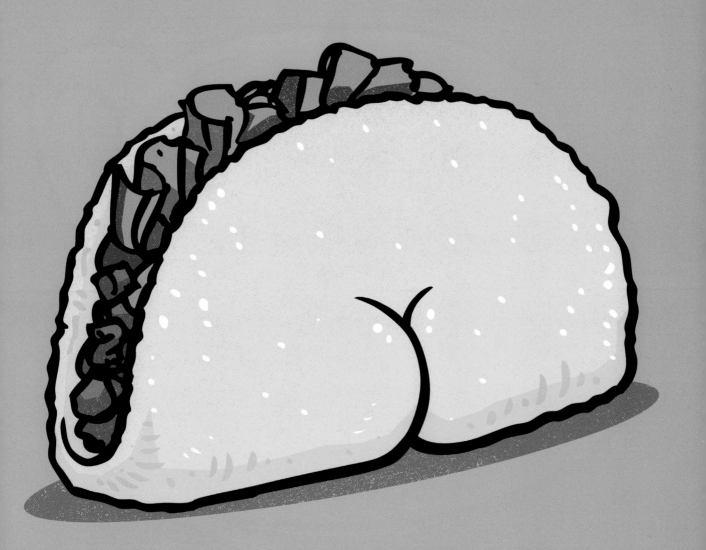

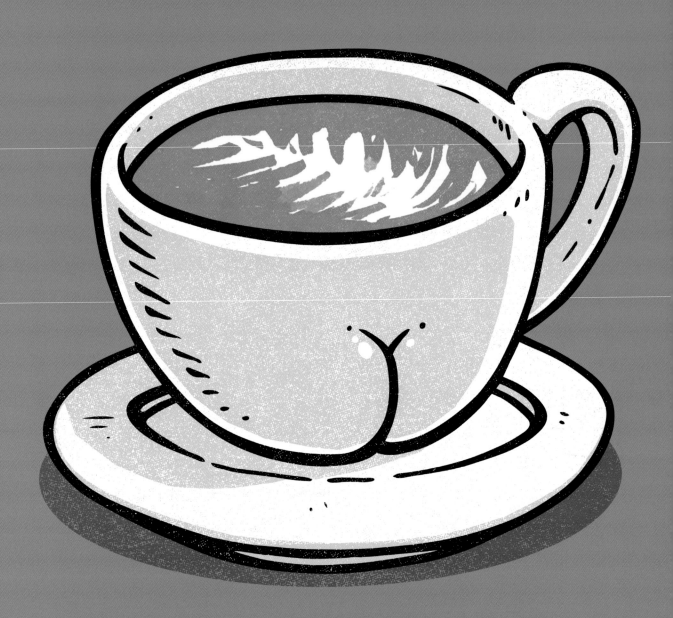

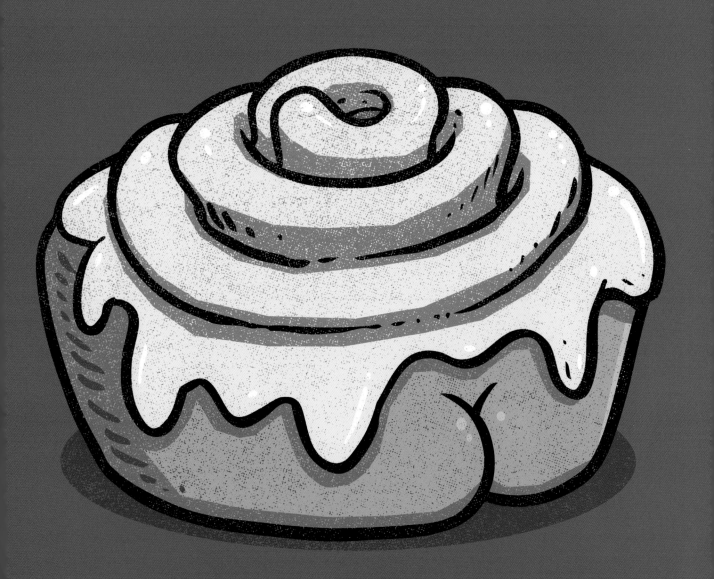

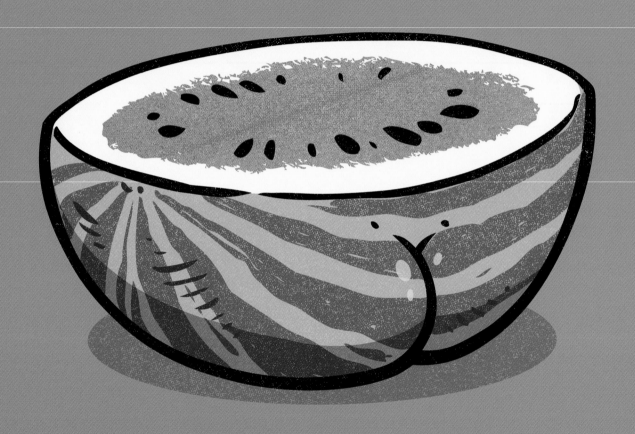

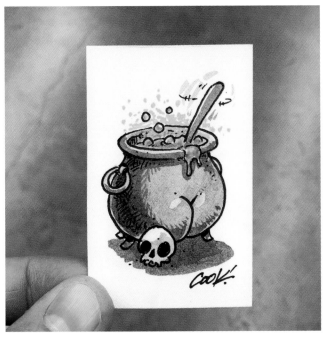

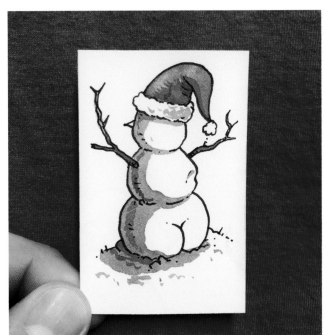

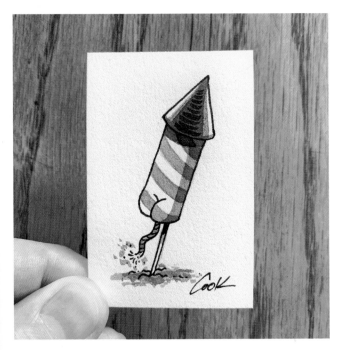

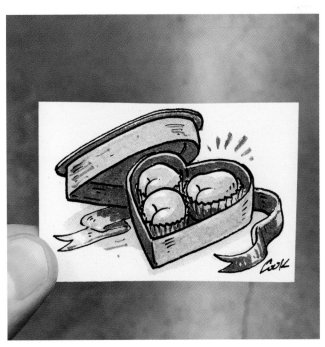

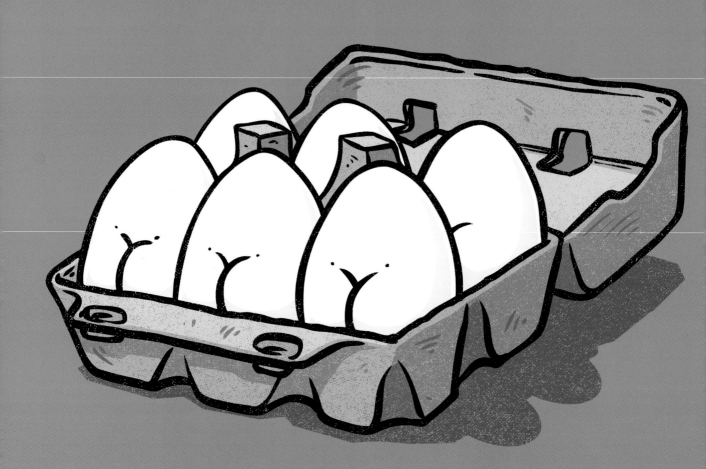

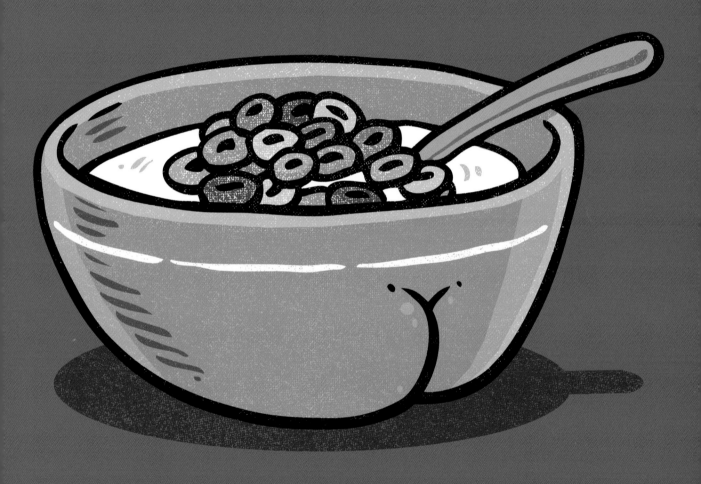

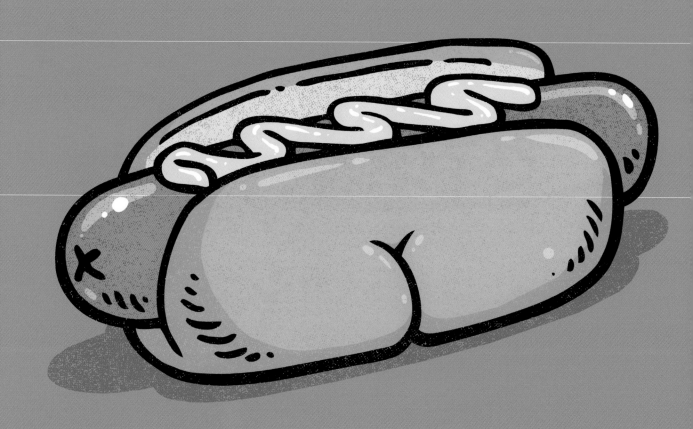

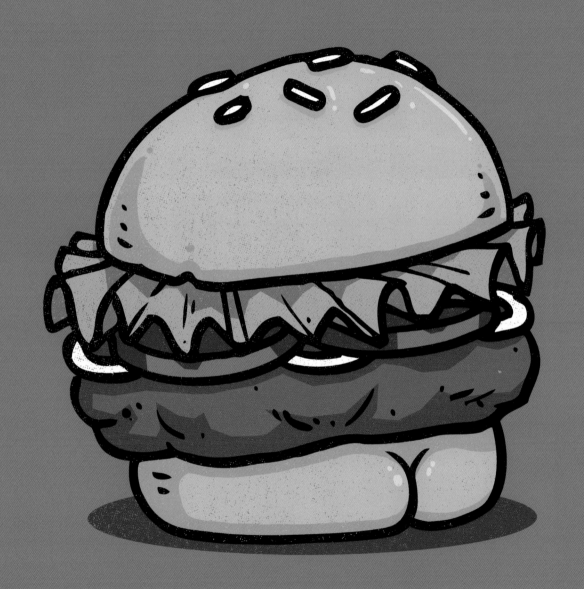

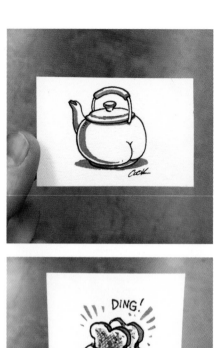
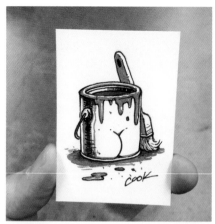
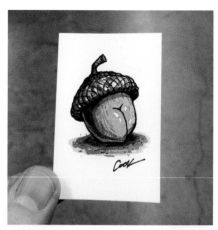
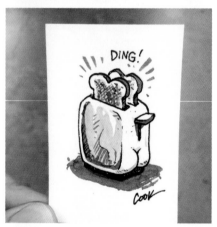
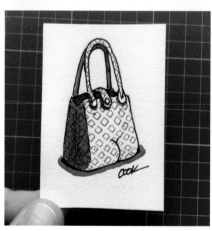
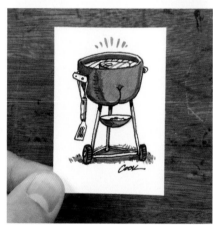

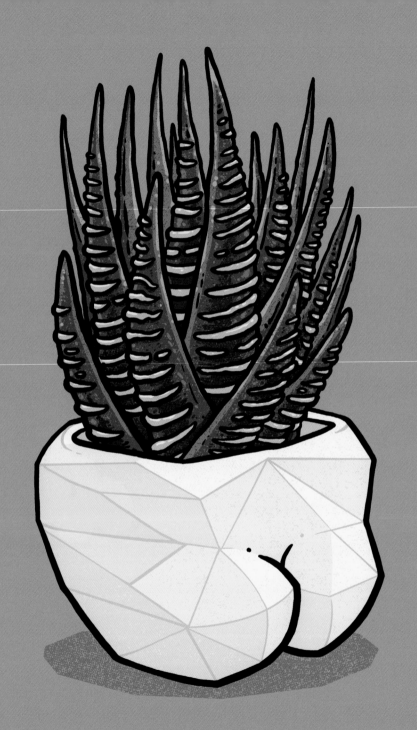

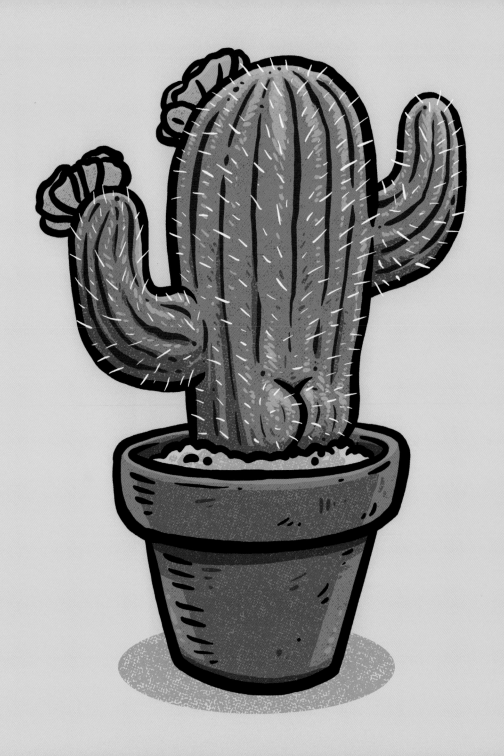

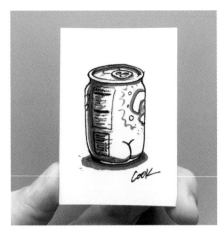
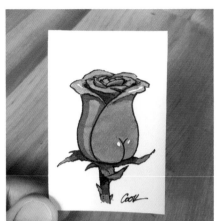
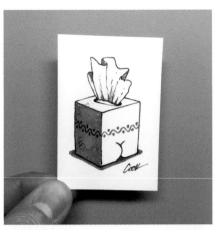
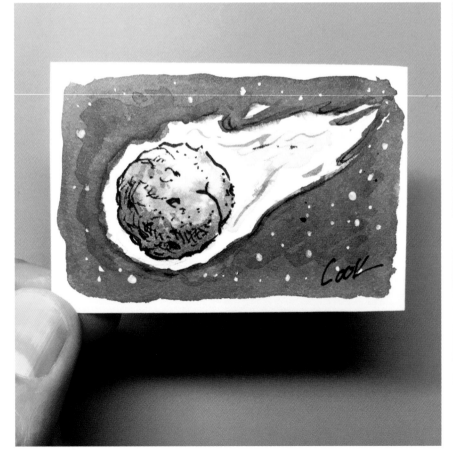
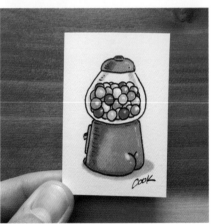
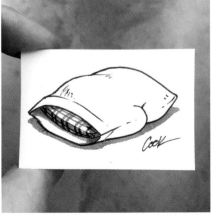

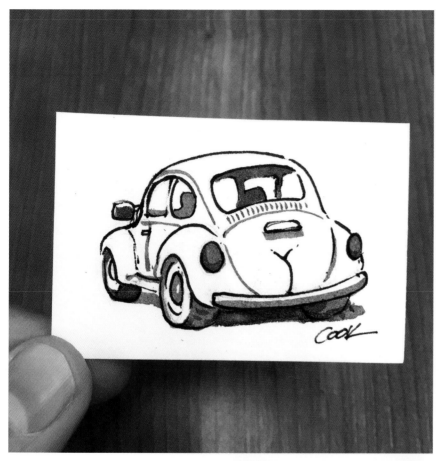

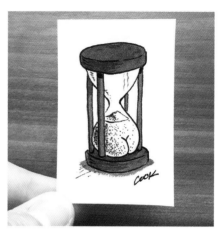

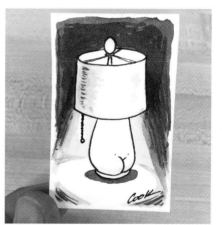

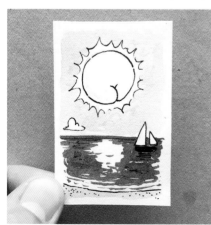

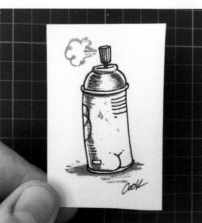

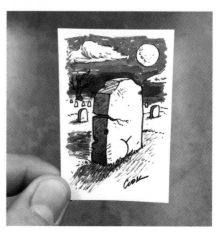

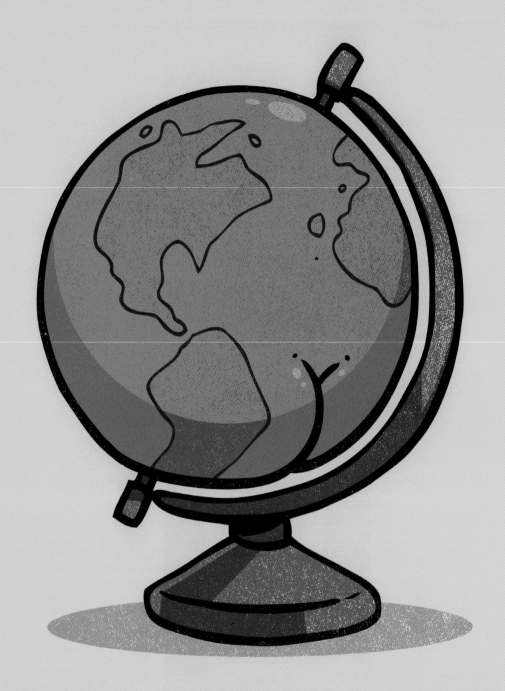

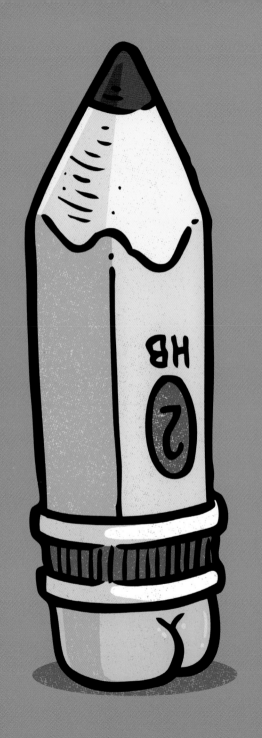

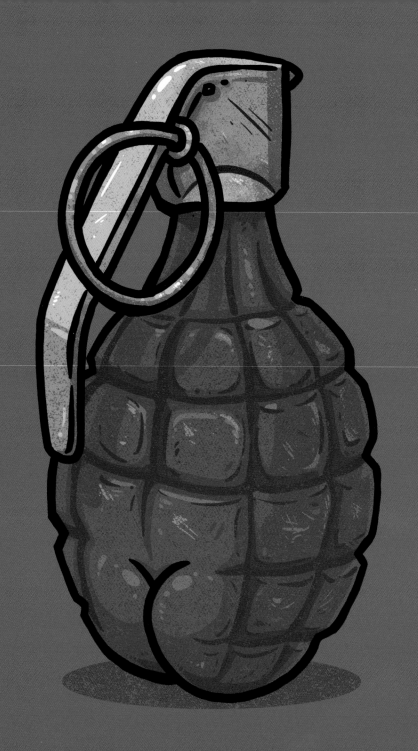

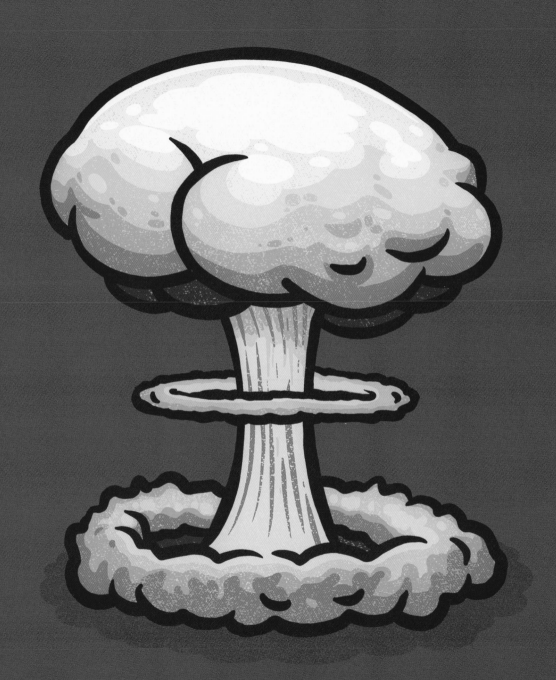

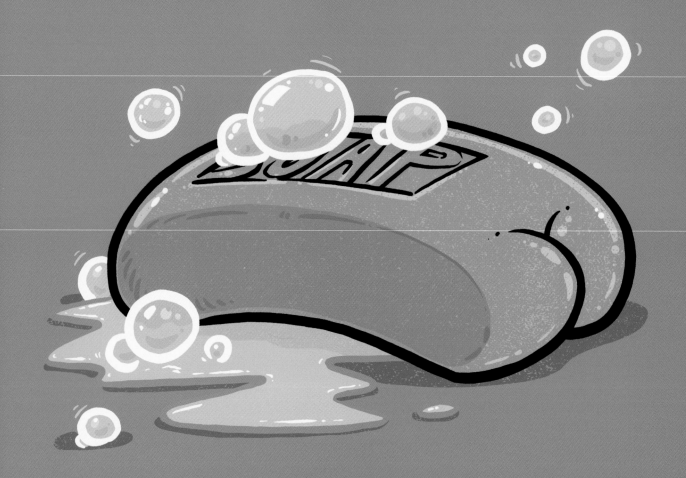

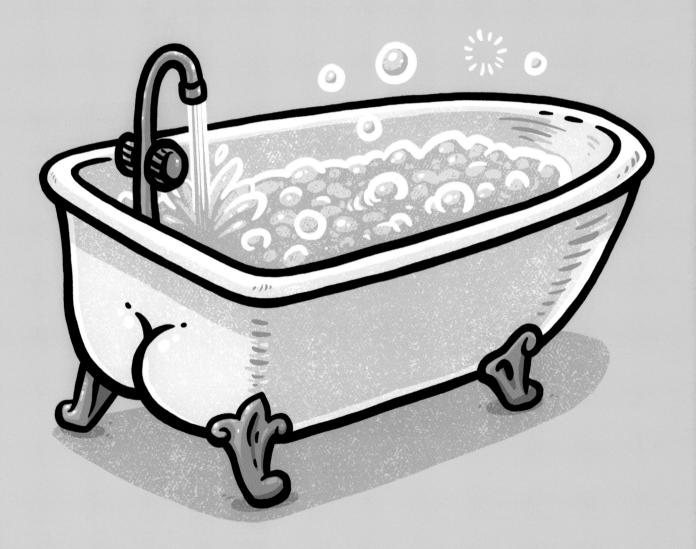

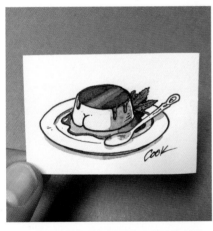

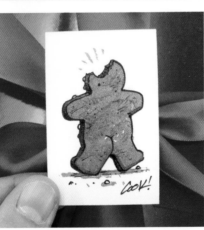

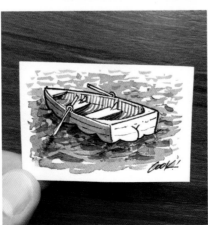

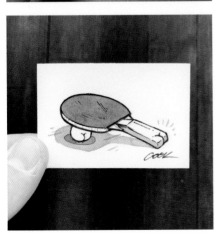

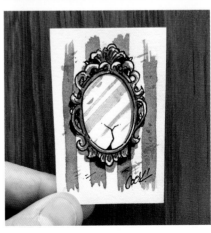

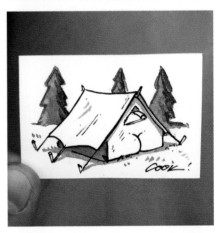

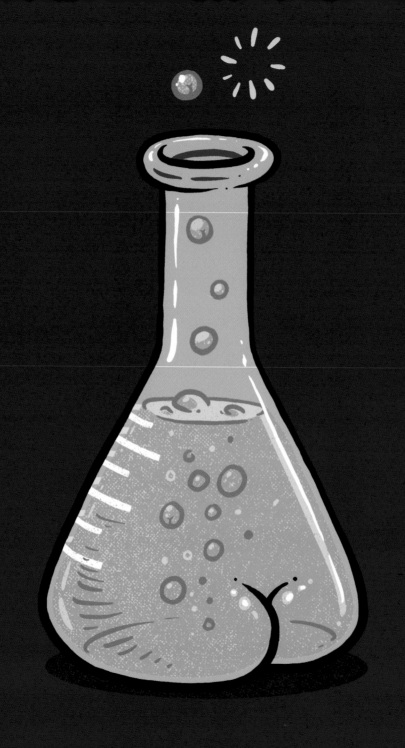

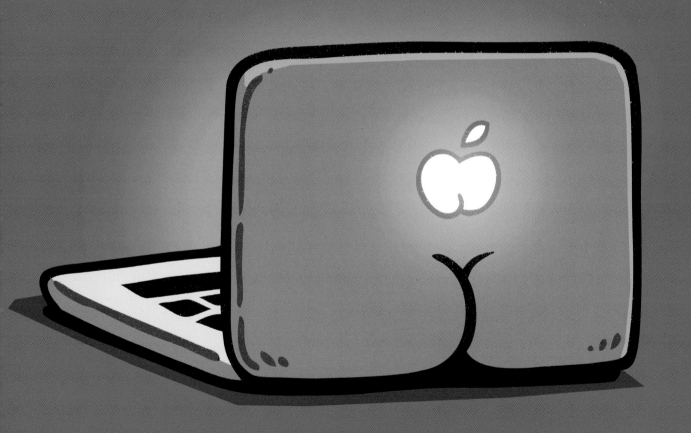

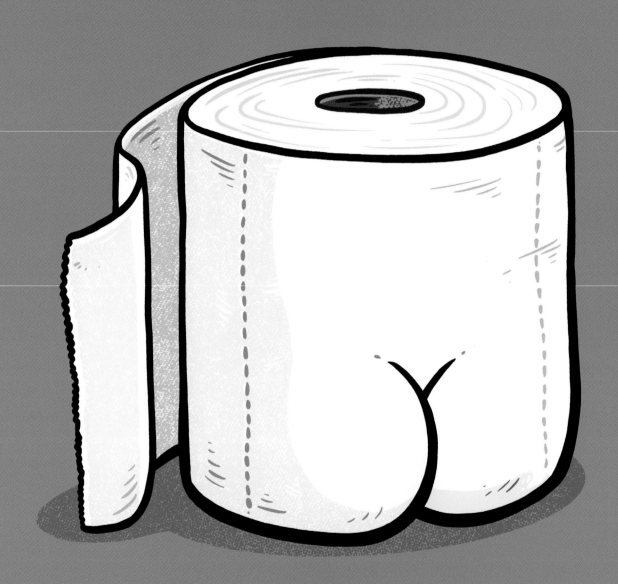

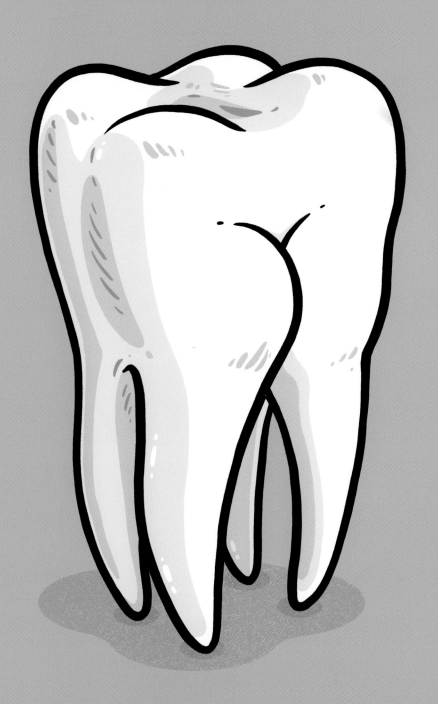

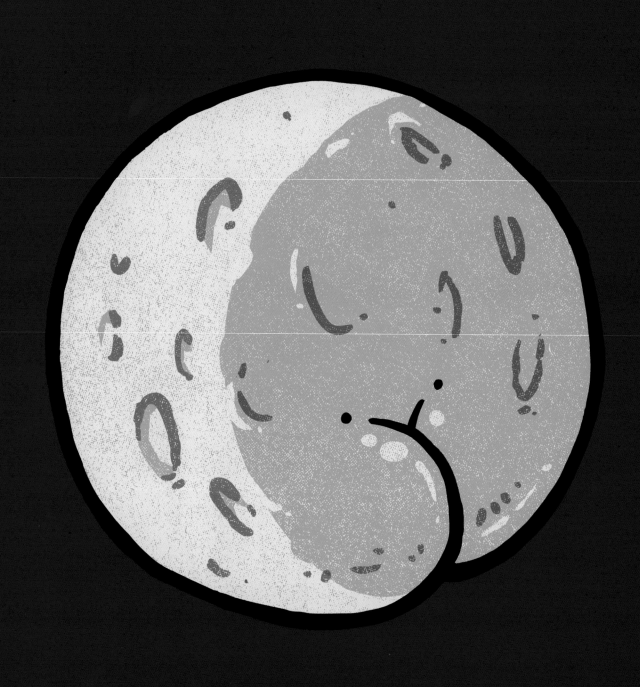

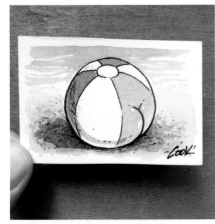 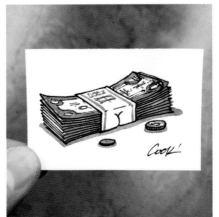 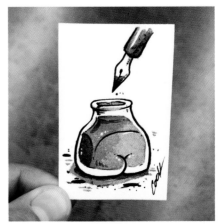

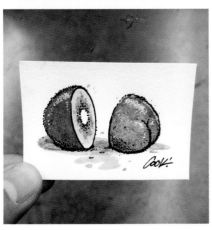 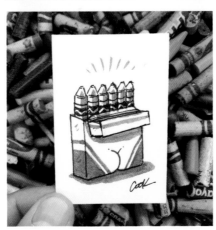 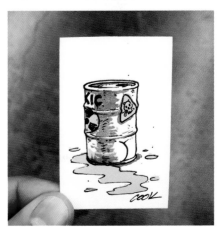

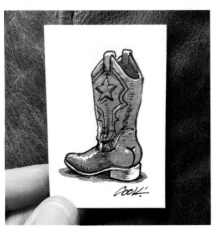 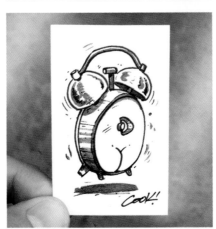 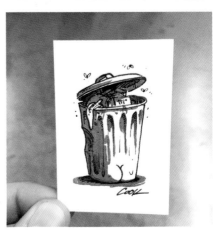

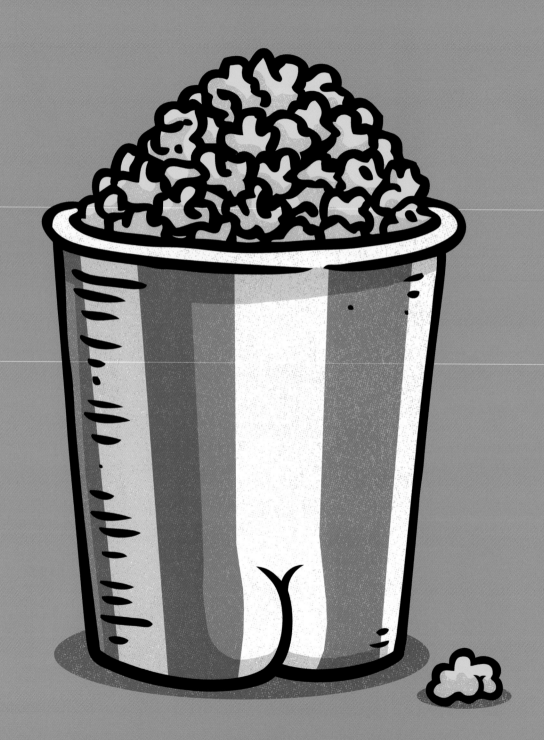

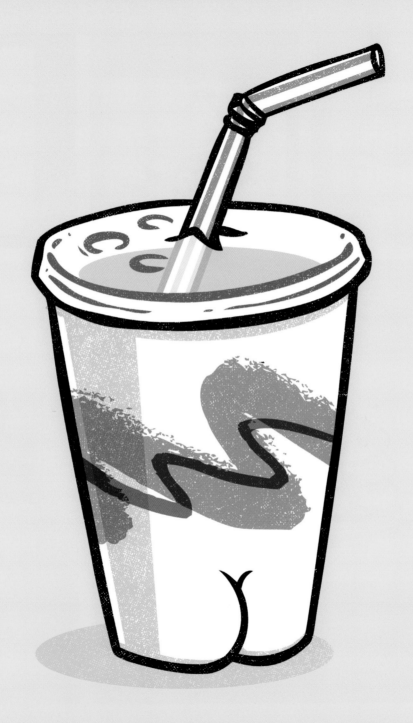

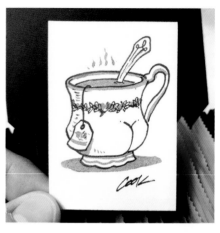

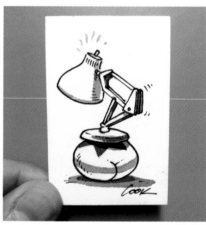

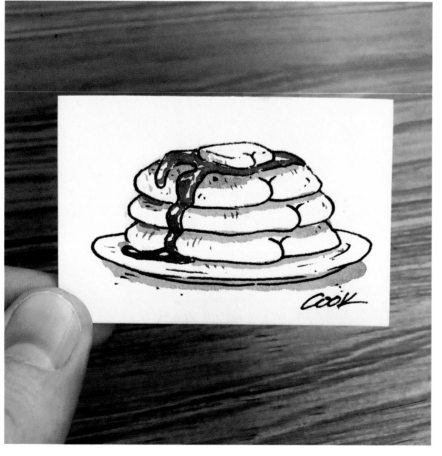

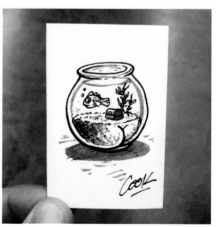

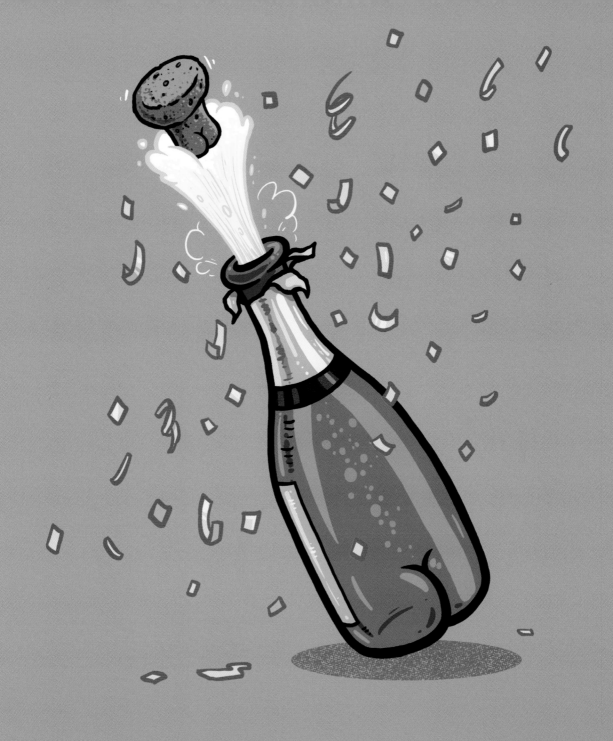

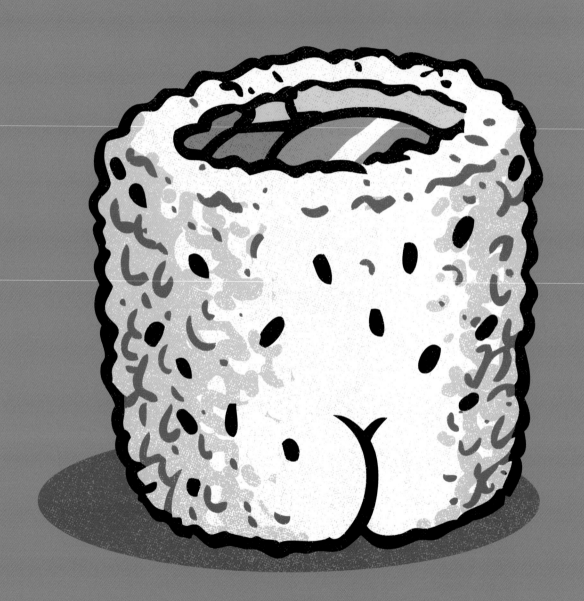

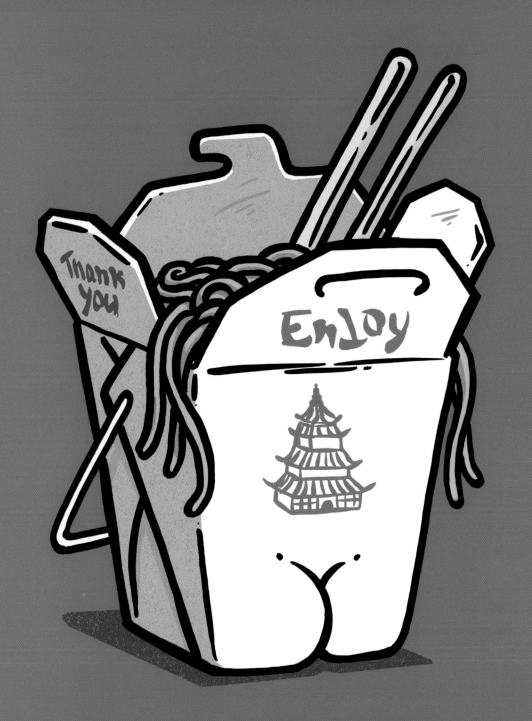

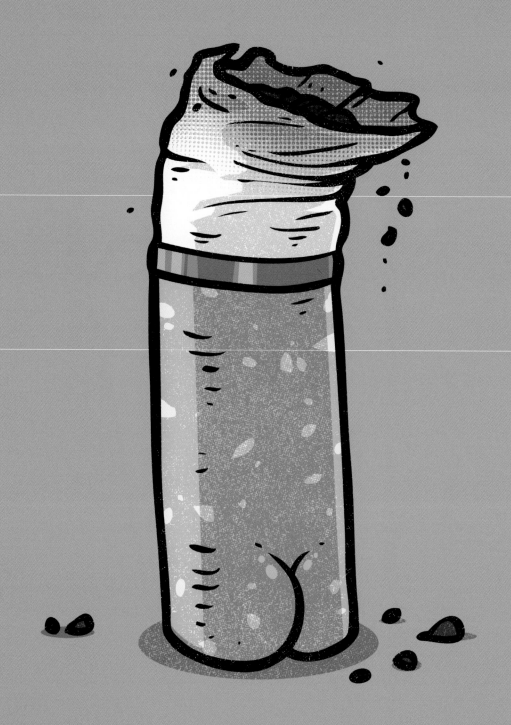

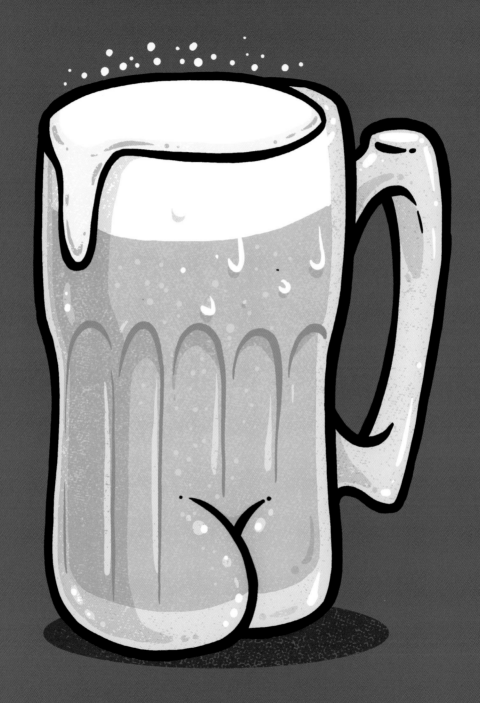

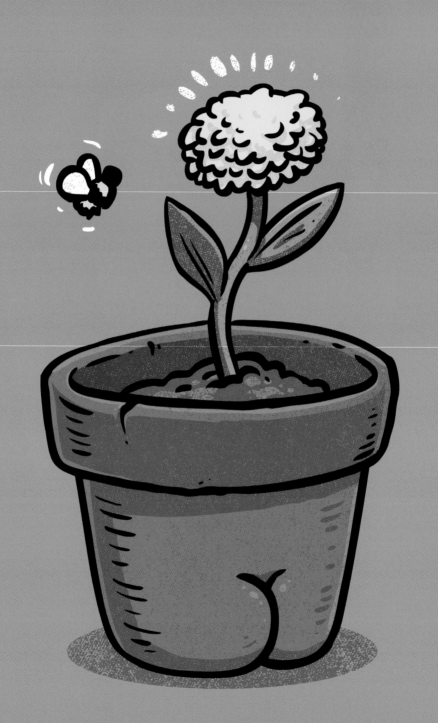

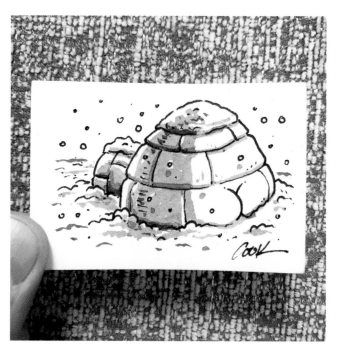

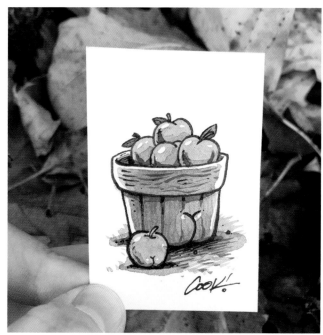

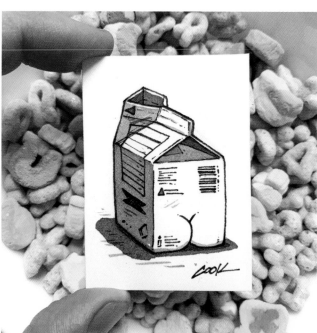

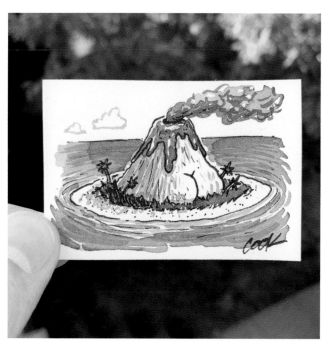

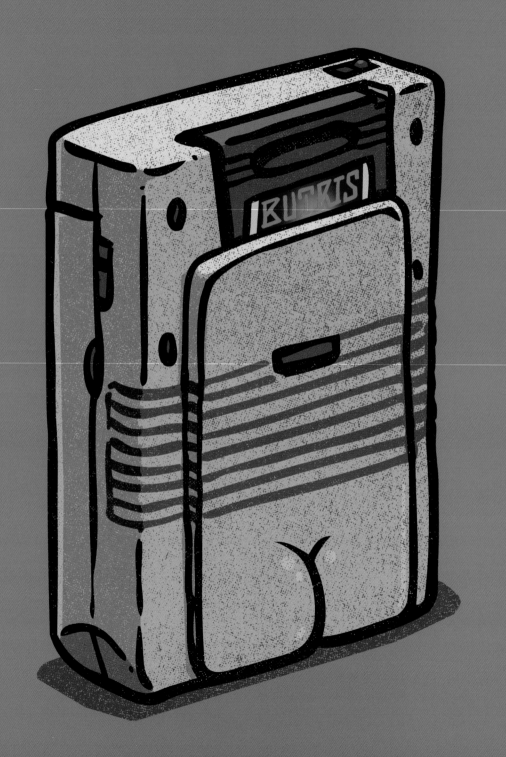

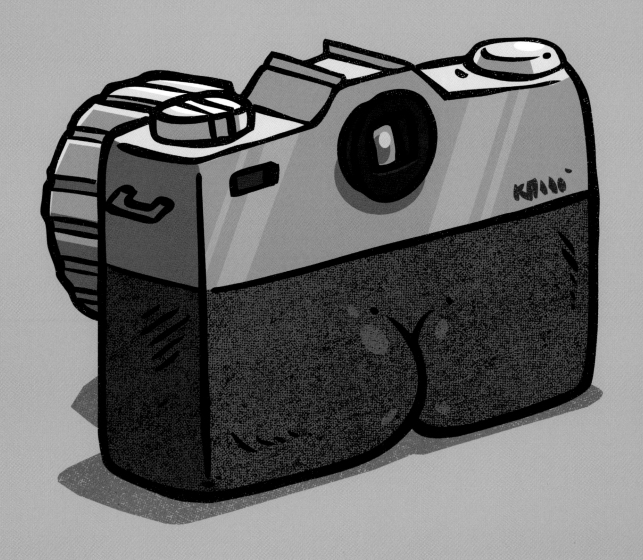

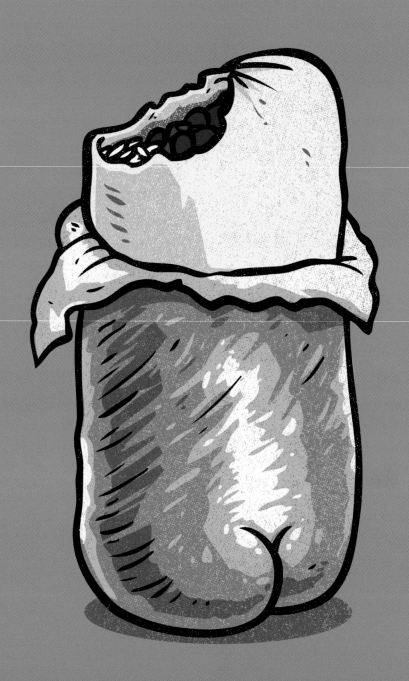

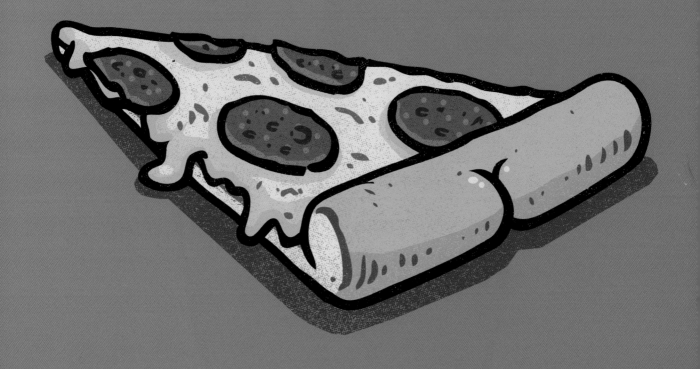

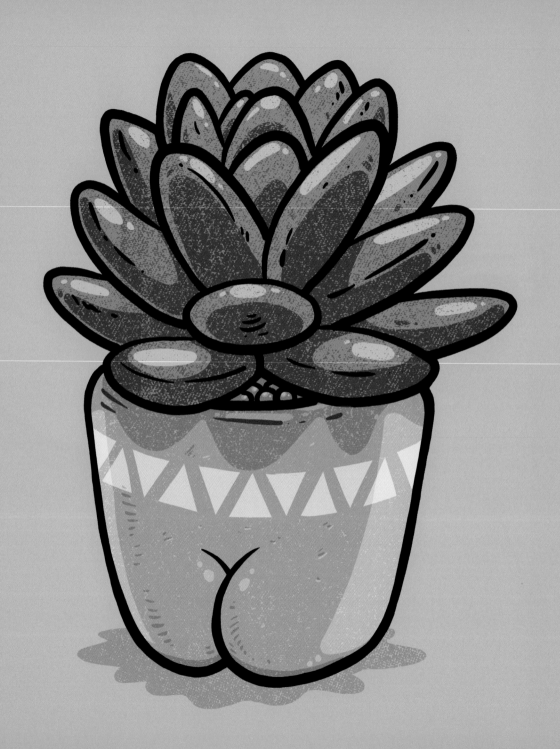

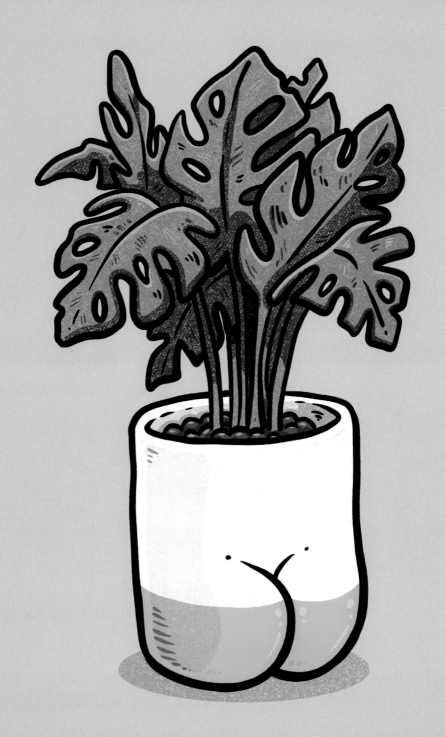

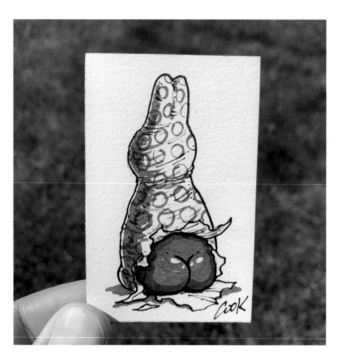

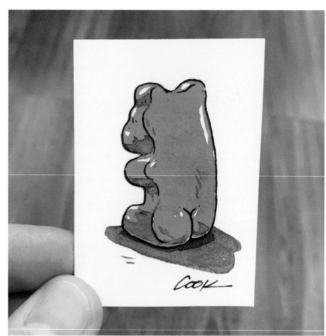

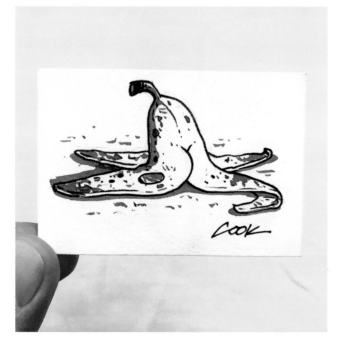

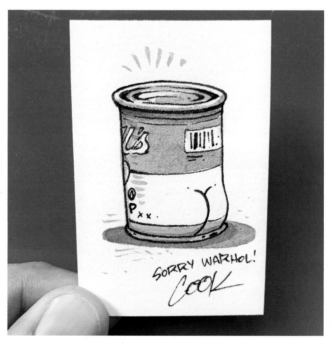

SORRY WARHOL!

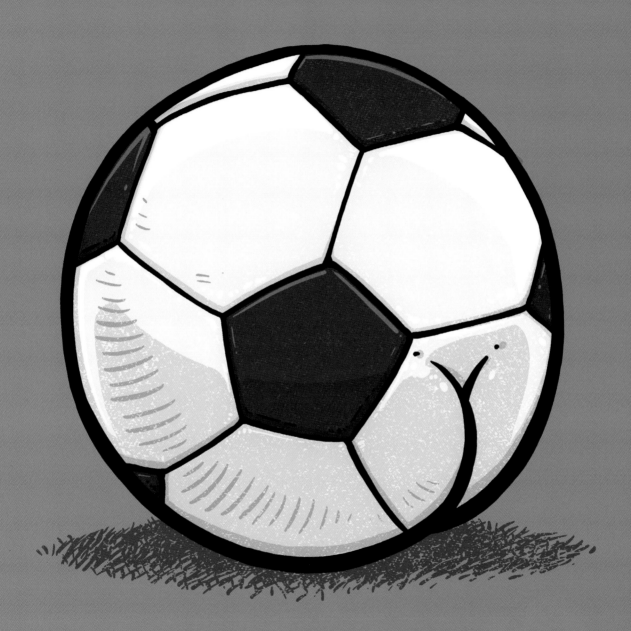

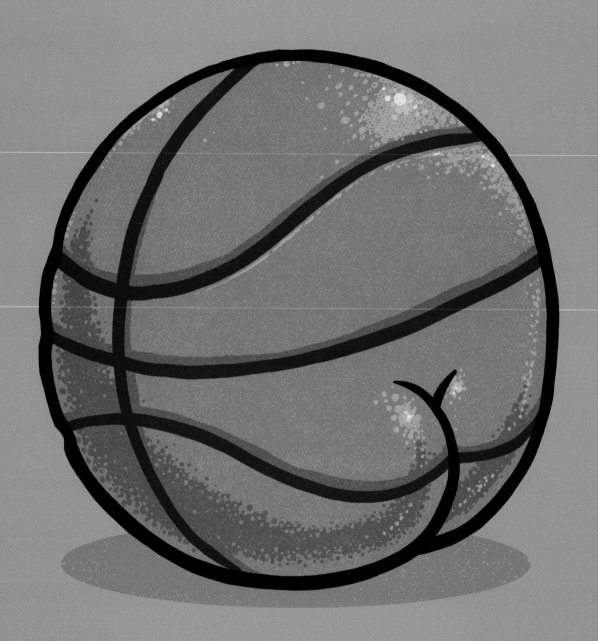

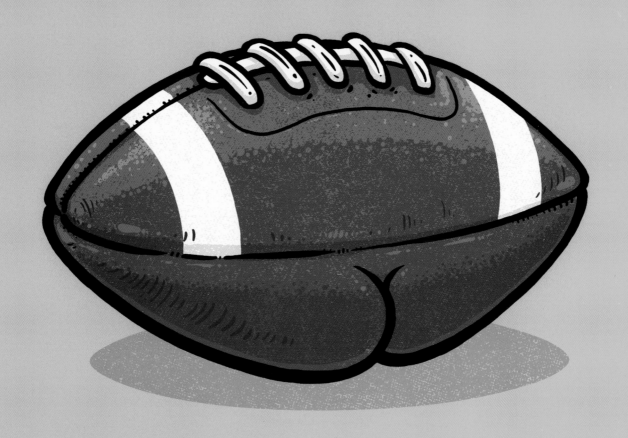

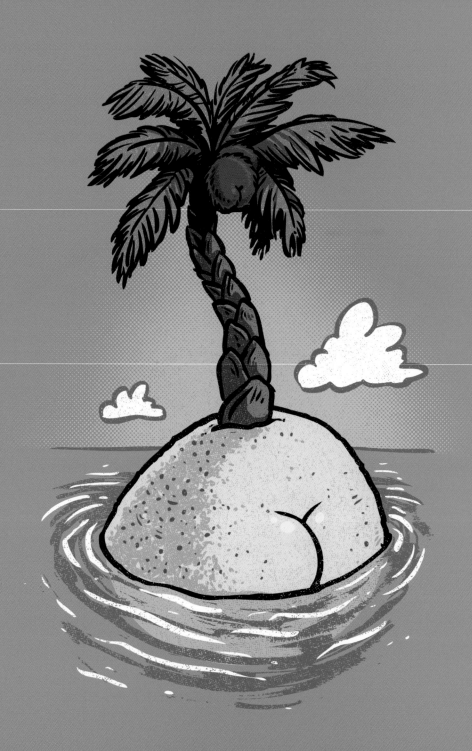

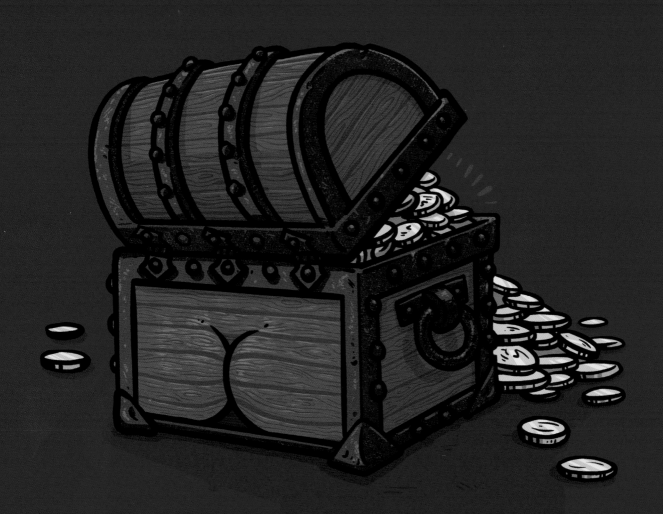

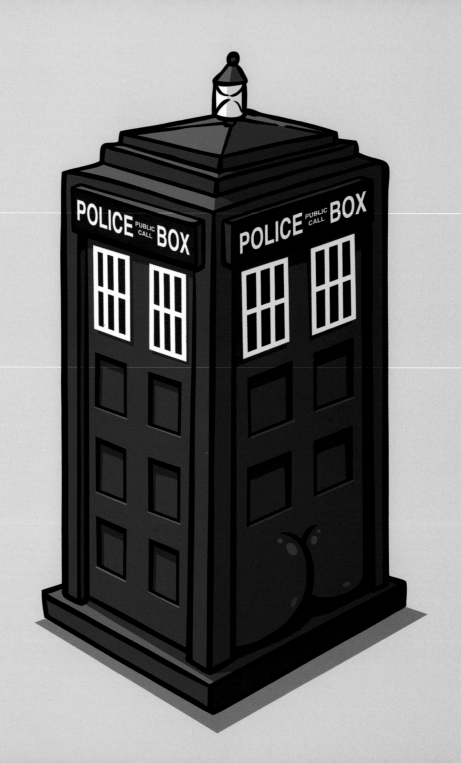

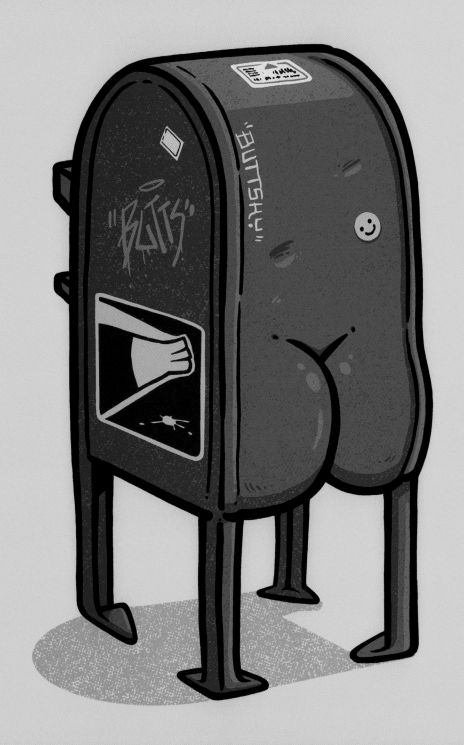

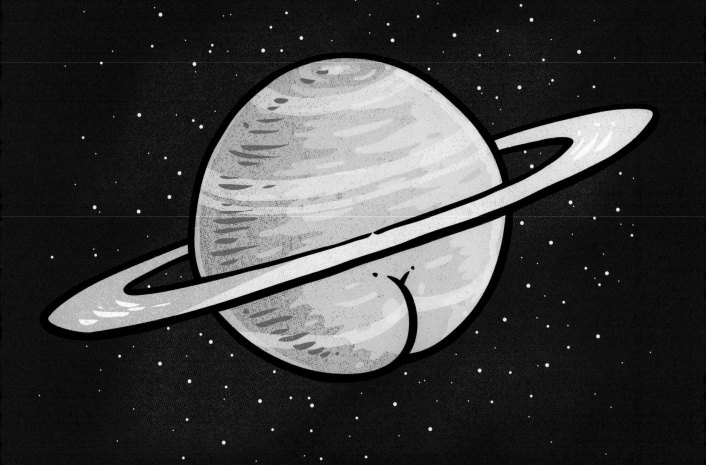

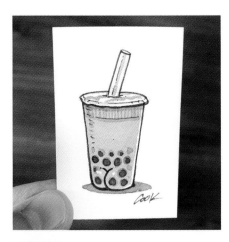

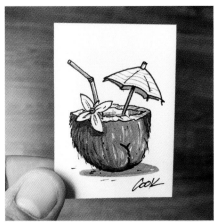

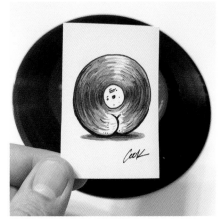

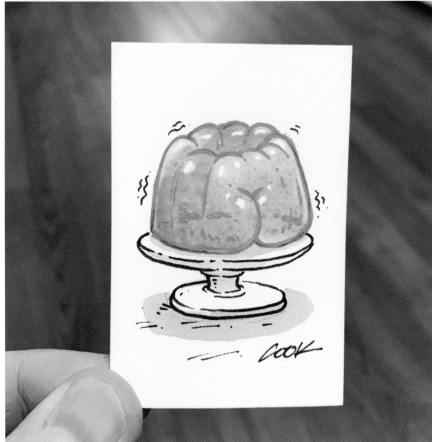

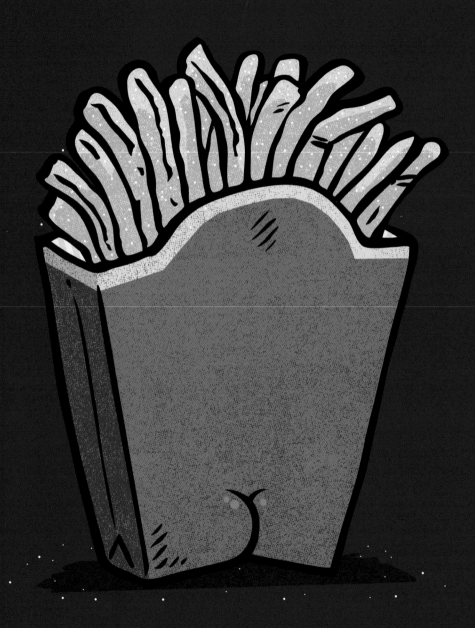

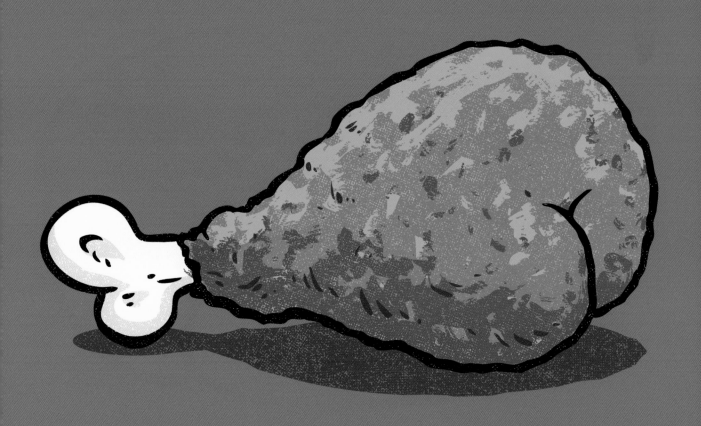

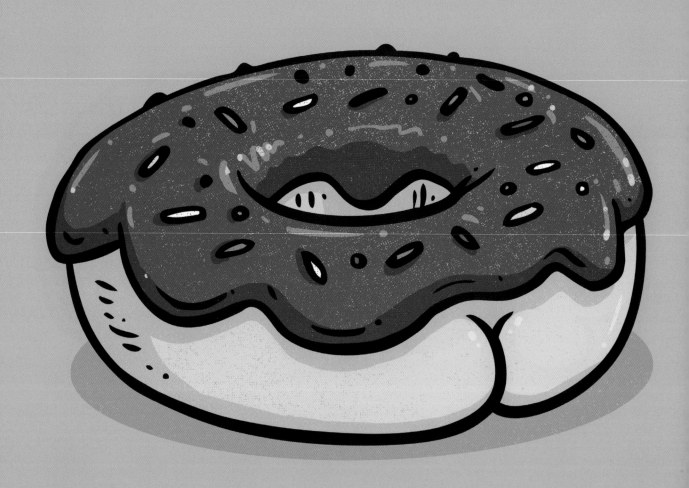

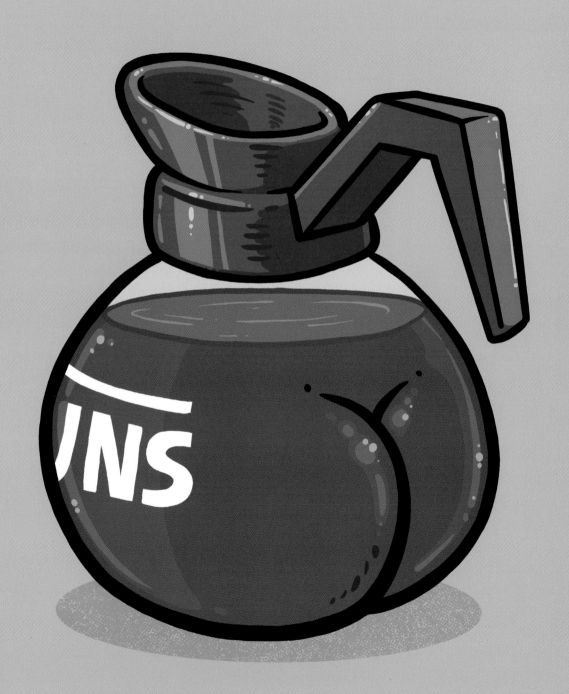

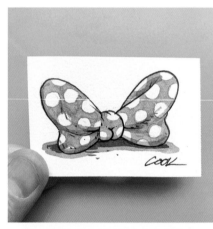

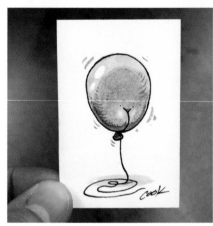

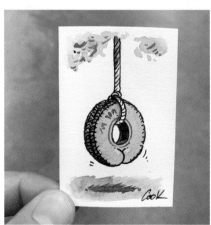

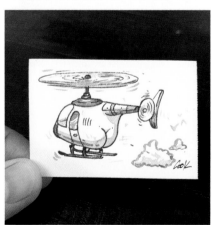

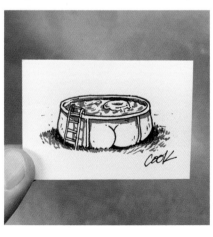

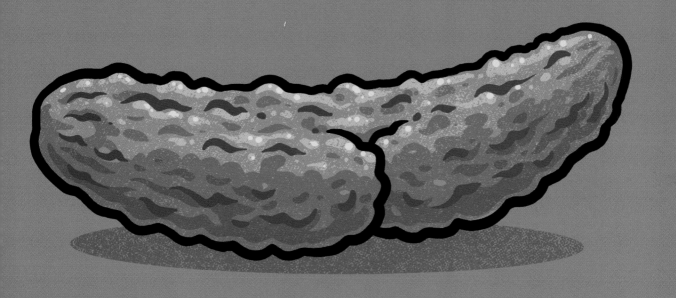

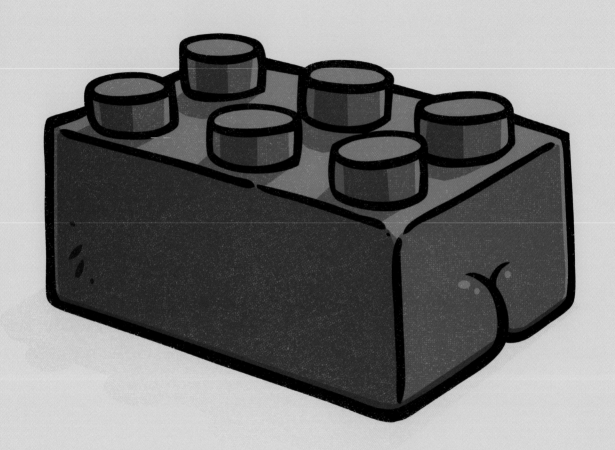

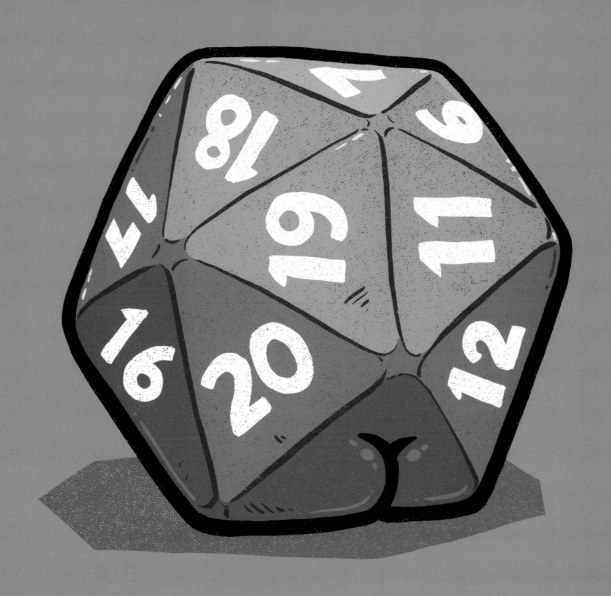

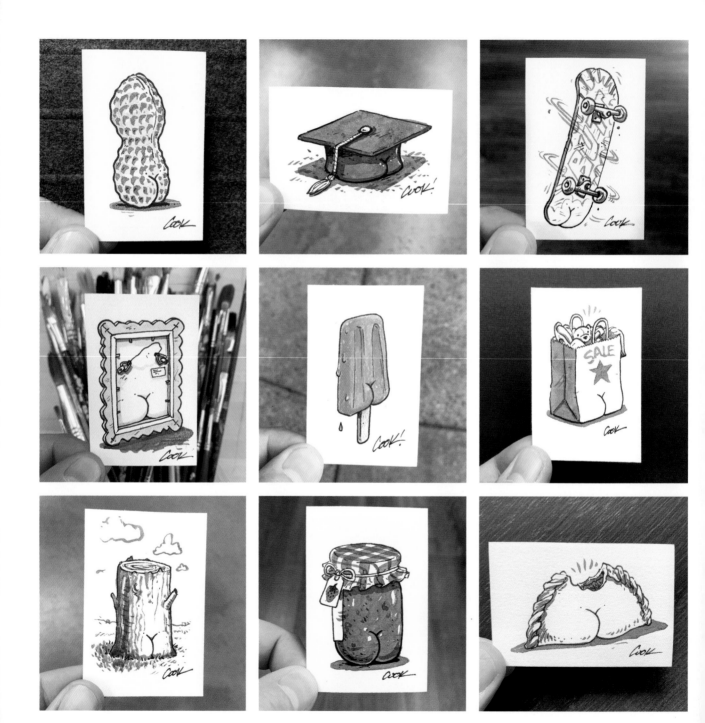

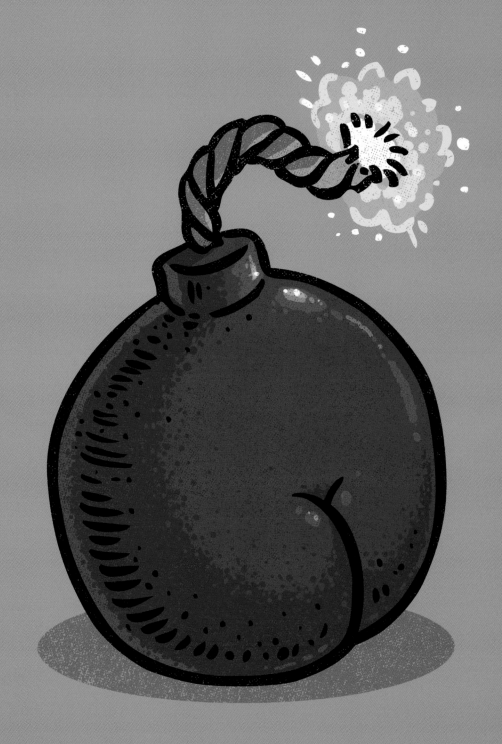

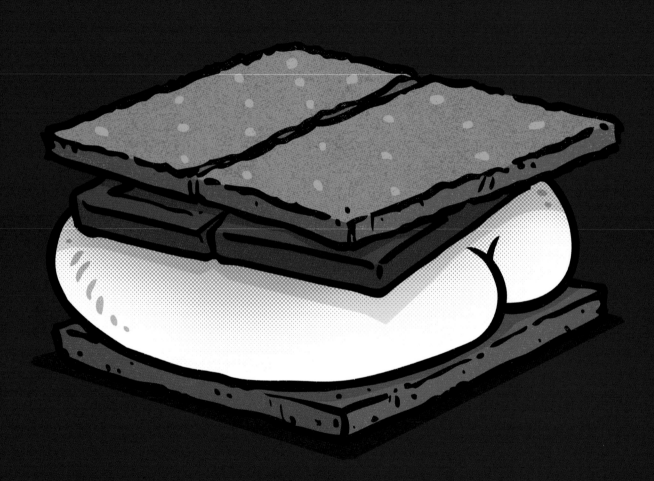

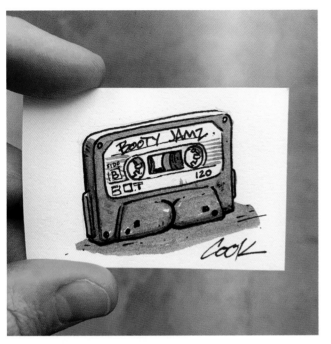

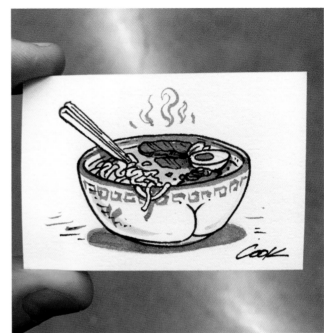

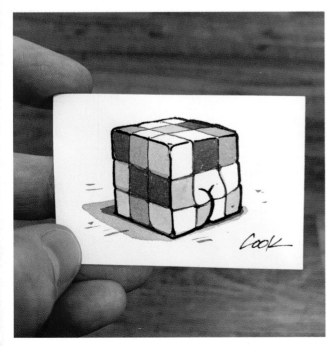

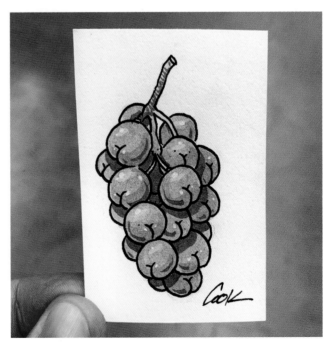

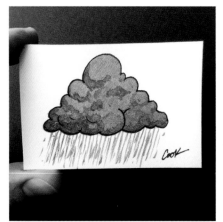

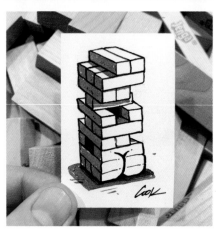

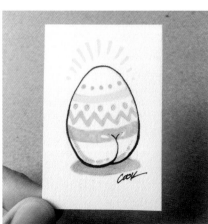

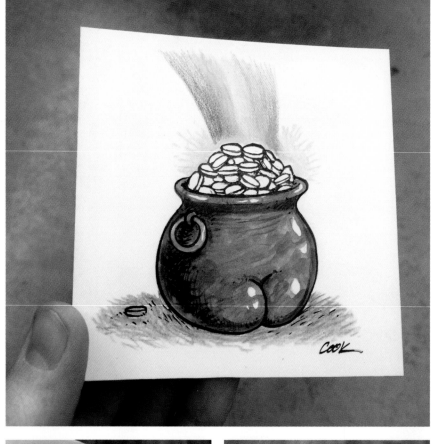

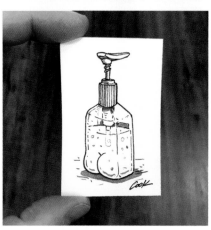

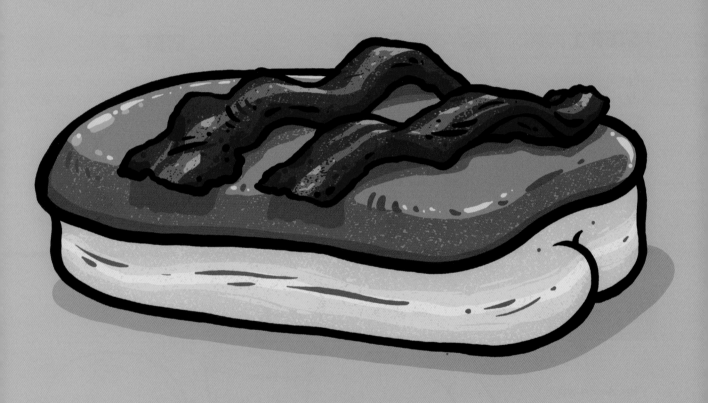

it's a Portland thing

HOW TO DRAW A BUTT!

WITH YOUR PAL, BRIAN COOK

Follow along and put me out of a job!

STEP 1

Sketch two circles.

STEP 2

First draw the cheek that will be in front.

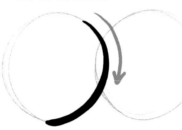

STEP 3

Draw the cheeks thin at the top and thicker at the bottom.

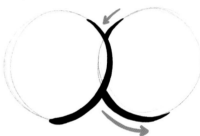

TIP!

The more you overlap the circles, the more the butt will appear to turn to the side!

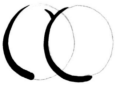

YOUR TURN!

DING!

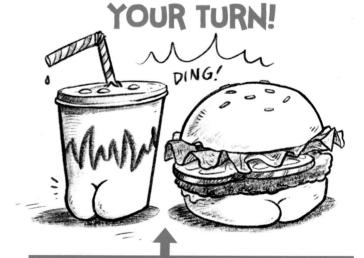

TAG YOUR DRAWING #BUTTSonTHINGS!